AIRBRUSHING
SHADOWS

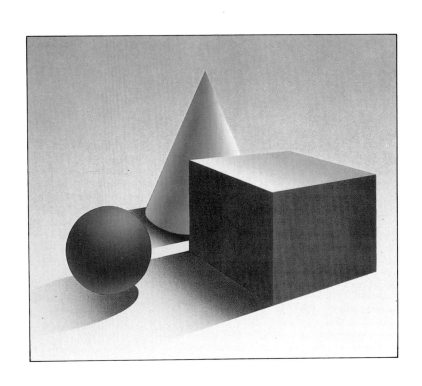

AIRBRUSH
ARTIST'S
LIBRARY

AIRBRUSHING
SHADOWS

JUDY MARTIN

Cincinnati, Ohio

This book was designed and produced by
QUARTO PUBLISHING PLC
The Old Brewery, 6 Blundell Street
London N7 9BH

SERIES EDITOR JUDY MARTIN
PROJECT EDITOR ANGELA GAIR
EDITOR RICKI OSTROV
DESIGN GRAHAM DAVIS
PICTURE RESEARCHER JACK BUCHAN
ART DIRECTOR MOIRA CLINCH
EDITORIAL DIRECTOR CAROLYN KING

Typeset by Ampersand Typesetting (Bournemouth) Limited
Manufactured in Hong Kong by Regent
Publishing Services Ltd
Printed by Leefung-Asco Printers Ltd, Hong Kong

A QUARTO BOOK

First Published in the USA by
North Light Books, an imprint of
F & W Publications, Inc
1507 Dana Avenue
Cincinnati, Ohio 45207

ISBN 0-89134-279-6

CONTENTS

PATTERNS OF LIGHT AND SHADE

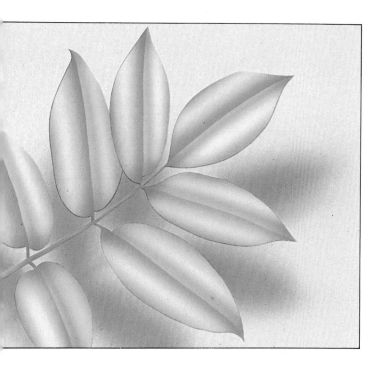

Light is the phenomenon which displays to us the spatial world and the shape of things. Shadows represent an absence of light in relative degrees: yet the various forms of shadows provide a great range of essential information, explaining the contour and volume of solid objects, describing their location in a particular context and in relation to neighboring objects, and indicating the quality and direction of the light source which illuminates them. In terms of two-dimensional representation, shadows provide the definition and depth of an image and can also serve to establish a special mood or atmosphere which the artist wishes to convey.

The projects in this book investigate the function of shadows in different contexts and the graphic means of representation in airbrush art. The pattern of light and shade across the form of an object is the element which describes its surface appearance: not only the angles of changing planes and degrees of curvature in volumetric terms, but also the texture and quality of a particular material. The artist translates these elements into a scale of tonal values, in the same way that a black-and-white photograph

ots three-dimensional forms in two dimensions, and integrates em with the color cues that contribute other means of cognition.

One of the major techniques of airbrushing directly reflects is process of mental analysis which the artist applies to a ainted rendering. When working with a transparent medium ich as watercolor or ink, the process of building an image must ollow a pattern of working from dark to light — because light ones or colors do not register when overlaid on a darker area ue to the transparency of the medium itself and of the fine irbrush spray. Several of the airbrush exercises in this volume emonstrate this principle very directly; the shadow areas are eveloped in a monochrome range before the surface color is verlaid in fine "glazes" of evenly applied spray.

This is an ideal way of interpreting the subtleties of tonal ontrast: highlights emerge from within the rendering of the hadow detail, as areas which have received little or no color. he sequence of spraying must be well thought out, however, nd a clear initial drawing of the subject provides the opportunity o plan the masking methods which will achieve the appropriate ffect.

Hard masking and loose masks are combined to describe he variations of shadow effects, which sometimes require distinct ard edges marking high tonal contrast, and at other times pass hrough almost imperceptible degrees of gradation within a mited tonal scale. Much of the work in a complex image is arried out freehand: the artist must be able to manipulate the pray quality smoothly, using the button control on the airbrush, nd also the range of the spray according to the distance of the irbrush from the working surface.

Some airbrush artists prefer to use gouache, an opaque medium, for spraying. In this case, the layering process used in watercolor work cannot be imitated, as a build-up of gouache spray gradually obliterates the previous layers of color. Color mixing is done in the palette rather than on the sprayed surface, requiring more frequent color changes. But the main advantage of working in an opaque medium is that a pale color, or pure white, can be laid cleanly over a darker tone, so the artist has greater opportunity to amend errors and adjust the overall balance of tone.

These technical considerations are applied in the same way to the rendering of cast shadows, the shadows caused by objects blocking the path of light. Cast shadows, by emphasizing the ground plane, locate an object in space, and can also be used to increase the sense of atmosphere in an image. The shadow forms a more or less distorted silhouette of the object on a different plane. Exaggerating this effect produces a sense of drama or underlines, for example, the effect of distance in a long perspective view.

However, cast shadows do not only function as an additional description of the overall contour of an object, which may be thrown onto the ground or against a wall. They also form internal patterns: in a portrait, the nose casts a shadow on cheek or upper lip; in the complex folds of draped fabric, areas of cast shadow are intermixed with shadows describing the recesses of the form. These two elements combined increase the range and depth of an image.

A shadow is in many ways a negative form, but in graphic arts it plays a very positive role. It is fundamentally an effect of light, therefore the artist's means of interpreting light and shade are necessarily linked. The patterns created by shadows provide the key to effective rendering of three-dimensional form.

SHADOWS DESCRIBING VOLUME: BASIC FORM

The simple outline of a geometric form can be "read" three-dimensionally. We have become accustomed to graphic conventions which enable us to interpret sometimes quite minimal data; the brain supplements the given visual information with existing knowledge of contour and volume. The less information that is presented, however, the more chance of the viewer interpreting wrongly. Even the simple cube can be read in outline as either a projecting shape with the planes covering the interior, or a receding, hollow box.

Tonal detail eliminates this ambiguity by establishing a distinctive relationship of planes, emphasizing edge qualities between changing angles and using highlight and shadow to describe levels of projection or recession. The step-by-step example here produces a solid cube in which the leading top corner is thrown into relief by the dark shadow on the right-hand plane. Each plane has a different tonal value, contrasting light, medium and dark tone. The different effects of light and shade applied in the individual examples (far right) preserve these contrasts, although they are differently distributed.

CUBE

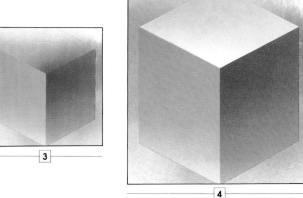

Draw the cube in outline and cover the image area with masking film **1**. Remove the masking film from the right-hand plane of the cube. Spray with graded tone, darkest at the far top corner and lightening gradually toward the lower front edge **2**. Unmask the left-hand plane and spray graded mid- to light tone, working from the outer edge to the front corner **3**. Finally, unmask the top plane and spray lightly graded tone from the back to the front corners of the cube **4**.

When the color is dry, remove background masking **5**. In the completed image, the leading edge and front top corner of the cube show the strongest illumination, grading into darker tones toward the farthest edges of the form. To emphasize the three-dimensional effect, the tonal gradation that gives the form solidity has been contrived to create a distinct contrast on either side of each edge between adjacent planes. The convention of shadowing each plane differently to model the form can be applied in different ways, as shown in the examples at right.

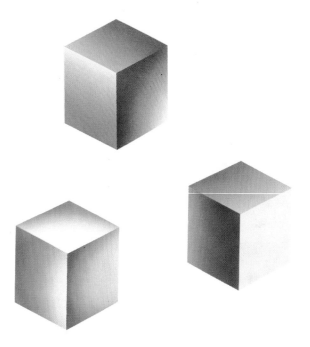

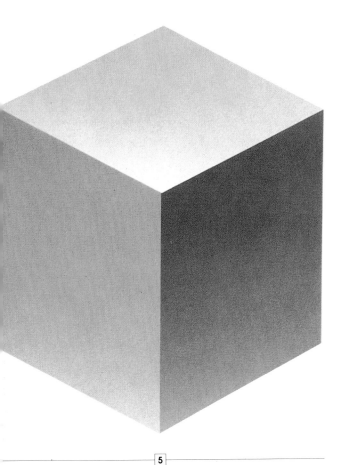

An impression of angled lighting is created by highlighting the top edge of the left-hand plane (top) and darkening the horizontal face of the cube. Flat illumination from the right emphasizes the contrast between planes (above right) but narrows the tonal scale within each area. Increased contrast in the tonal gradations of each plane creates a dramatic effect (above left).

CAST SHADOWS: GROUNDING THE OBJECT

The shadow pattern that describes the form of an object describes its solidity but does not include any information about the object's position in space: on a flat background, the solid object appears to float. Cast shadows are the element which locate an object in terms of its relation to horizontal and vertical planes, and to nearby objects.

The main exercise on these pages explains how to airbrush a cast shadow to produce a realistic tonal effect consistent with the volumetric shadows on the cylinder. The size and density of a cast shadow depend upon the angle and strength of illumination cast on the object. In strong overhead light, the shadow is truncated and heavily toned; with weakening light from a low angle, the shadow is extended and passes through a gradated tonal range (far right). The outline of the shadow is found by fixing the point of illumination and extending lines from that point across the outer edges of the object, traveling away from the light source (see also page 48).

When the shadow is cast over a nearby object, its form is plotted over each change of plane as shown in the example on pages 12 and 13.

1

2

3

4

raw the image in outline **1** and cover with masking film. Use tape
hinge the lower edge of the mask section on the curved face of
e cylinder, and peel it back. Spray a band of dark tone on the
ft-hand side and a wider band of graded tone on the right-hand
de as shown **2**. When dry, replace the mask. Unmask the elliptical
ace of the cylinder. Spray graded tone from the top edge **3**. Allow
dry and replace the mask. Lift the mask from the shadow area;
oray a graded tone of gray, darkest close to the base of the
ylinder **4**. Remove all remaining masking **5**.

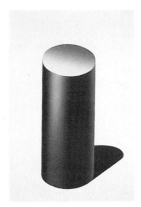

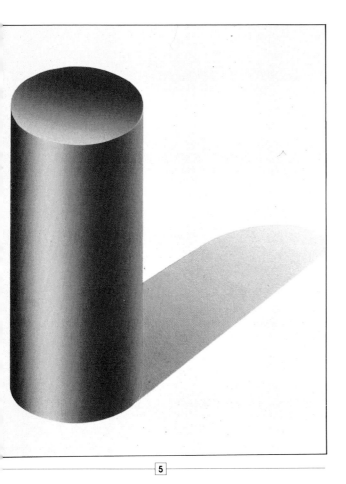

Variations of the shadow cast by the
same cylindrical form suggest
different qualities of illumination. In the first
version (top) the light source is strong and
falls from almost directly above the cylinder,
lightening the top plane and casting a solid,
truncated shadow. The opposite effect
occurs with the light coming from a lower
point to the left-hand side (above), casting
an elongated but softly graded shadow.

5

**CAST SHADOW ON
THREE-DIMENSIONAL
FORM**

1

2

3

4

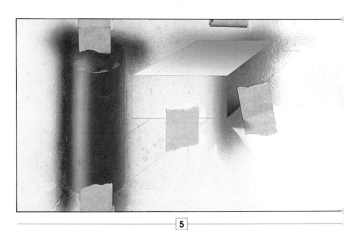

5

Draw the image in outline and cover with masking film **1**. As in the previous exercise, remove the mask from the curved face of the cylinder and spray with bands of graded tone at the left-hand side and right of center **2**. Remask when dry. Unmask the elliptical top plane and spray with graded tone from the top edge **3**. Lift the masking from the right-hand side of the rectangular box and spray dark-to mid-toned green **4**. Allow the color to dry and lift the masking from the top plane; spray with mid- to light tones of green as shown **5**.

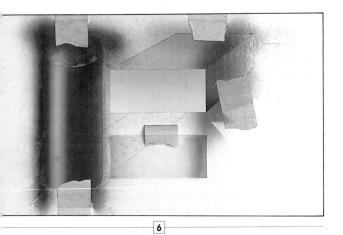

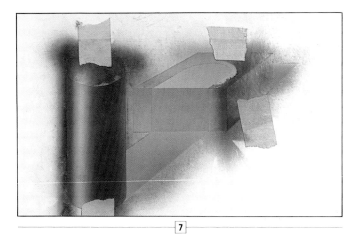

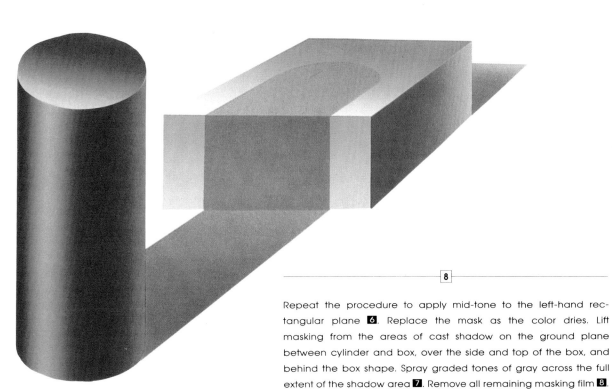

8

Repeat the procedure to apply mid-tone to the left-hand rec-
tangular plane **6**. Replace the mask as the color dries. Lift
masking from the areas of cast shadow on the ground plane
between cylinder and box, over the side and top of the box, and
behind the box shape. Spray graded tones of gray across the full
extent of the shadow area **7**. Remove all remaining masking film **8**.

CAST SHADOWS

SIMPLE RING SHAPE: FLAT PLANES AND CURVES

As with the cube, described on pages 8 and 9, the application of shadow to the planes of this simple ring shape provides a specific sense of its solidity and weight. The step-by-step sequence shows the most basic form of shadowing – a contrast of light tone on the cross-section of the ring and dark tone on the inner and outer curves – which emphasizes its depth. This is a schematic way of describing volume with flat tone: the graphic style is particularly effective in airbrushing because of the even texture which can be obtained across the sprayed color areas.

The methods of modeling the surfaces with tonal gradation (far right) introduce variations in the light source assumed for each rendering. The shadows describe the curves in a more complex way that suggests qualities of surface texture – the hard contrasts indicate a reflective surface, while the softer gradation gives a matt effect. The lighter tones even seem to imply that the object is lighter in weight than the heavily modeled examples. These different renderings also provide a general indication of how shadows set a mood within a given context: this is further explored in later projects.

1

2

3

aw the image in outline and cover the artboard with masking film
. Cut all the outlines in the mask. Lift the mask sections from the
adow areas inside the ring shape and around the outer edge.
ray with a flat tone of deep blue **2**. When the color is dry, replace
e mask sections over the sprayed shadow areas. Lift the mask from
e flat face of the ring shape and spray with an even tone of light
ue **3**. Allow to dry and remove all the masking film **4**. Although
rayed with only two tones, the ring shape stands out three-
mensionally against the white ground.

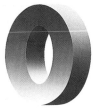

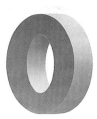

Graded tones applied to the faces of
the solid ring give greater subtlety in
the three-dimensional modeling. Evenly
balanced tone is broken up by a strong
highlight and heavy inner shadow
suggesting a powerfully directed light
source (top). Softer gradations are
employed in alternate contrasts of light and
shade around the form (above left) and a
brilliantly lit rendering with interior highlight
(above right).

4

SHADOW PATTERNS: VOLUME AND SURFACE TEXTURE

This exercise is designed to explain how tonal gradation and shadow patterns translate a basic geometric form into a representation of an actual object. The ring shape from the previous exercise is the basis of this formal rendering of a car tire. The outer curve is modeled with shadows on the receding surfaces to emphasize the effect of roundness: the shadow on the inner ring is at the top, because light passing through the center of the tire from behind illuminates the lower section of the curve. A new element is introduced in the use of zigzag lines of dark tone, the heaviest shadow element, to delineate the pattern of the tire tread. The cast shadow of the tire is also included to set it firmly on the ground plane.

In a similar way, linear or block shadow patterns can be used to build detail on a form of underlying geometric simplicity: curving lines of dark tone ringing a basically cylindrical form suggest the shaft of a bolt with screw thread; a cuboid form with the sides patterned by regularly spaced rows of tonal blocks can be transformed into a building with darkened windows. Breaking down a complex image into such simple formulas helps the artist to plan the stages of an airbrush rendering.

Draw up the image in outline and cover the artboard with masking film. Cut the zigzag lines of the tread pattern and lift the masking film from inside the lines. Spray with solid black **1**. Remove the masking from the circular face of the tire and spray with lightly applied layer of black to build up a graded dark gray tone **2**. Remask when the color is dry. Lift the masking from the curved face around the tread pattern. Spray with graded tone, creating a highlight area at the center **3**. Remove masking from the inner ring of the tire and spray with light tone **4**.

1

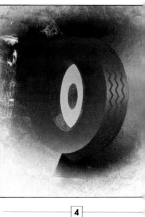

2

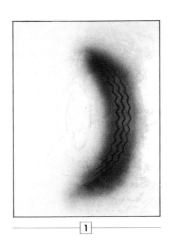

3

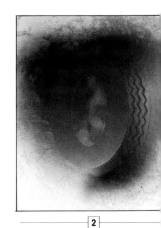

4

move the fine strip of masking film from the inner rim of the tire. ray with a light tone of gray **5**. Lift the remaining mask sections m the inner rings and spray lightly graded tone, slightly darker at e top of the curve and lightening at the base **6**. Allow the color to y completely. Remove the background masking and apply fresh asking film to the whole shape of the tire. Spray the cast shadow ading left from the tire base, fading off the color to form a loosely fined shape **7**. Remove the remaining masking film to reveal the ished image **8**.

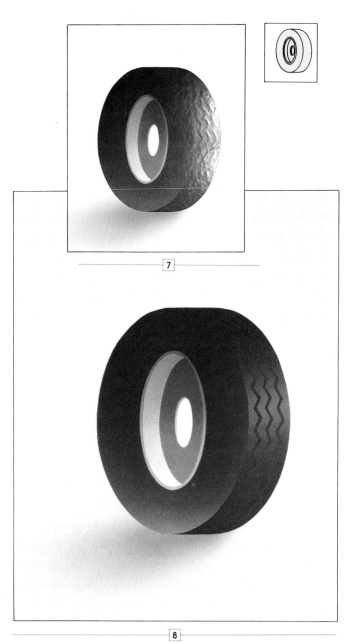

7

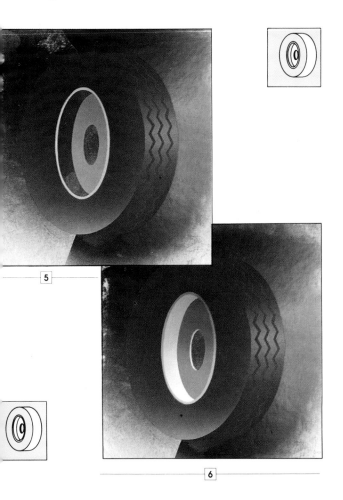

5

6

8

SUNLIT LEAF SPRAYS: ALTERNATIVE MASKING METHODS

Three projects are presented on the following pages which demonstrate how different solutions can be applied to the same visual problem, depending upon the effect required in the overall character of the illustration.

Each image describes a spray of leaves set against a sunlit wall, with a cast shadow directly echoing the leaf shapes on the surface behind. Variations in the techniques of masking and spraying provide soft-edged or hard-edged shadows. In the first example, the shadows are sprayed freehand after the coloring of the leaf shapes has been laid in over film masking. This gives a soft tonal gradation imitating the forms, giving an effect of gentle sunlight. In the second exercise, the leaf spray is given a hard-edged shadow using film masking to reproduce the leaf shapes precisely, suggesting harsh sunlight at midday. In the final example, graded tones are again used to create a subtle shadow effect, but a loose acetate mask is used as a template of the original form of the leaf spray. This allows the artist to develop the shadow detail from hard edges tracing the stem and leaf bases to a soft-edged effect at the outer tips of the leaves.

1

2

Draw the leaf shapes on artboard and cover the image area with masking film. Cut and lift the mask section on the lower side of each leaf below the center vein. Spray a graded tone of blue-green around the edges of each shape **1**. Lift the remaining half of the mask on each leaf and spray graded tone from tip to base above the leaf vein and along the outer edge **2**.

...erspray the leaves with a mid-green containing less blue than the ...eviously sprayed color, following the pattern of light and shade ...eady established **3**. When the color is dry, remove the back-...und masking and remask the leaves. Spray freehand to form a ...adow pattern of the leaves in sepia, repeating the shape of each ...m with soft-edged, lightly graded tone **4**.

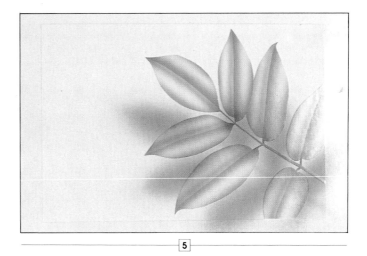

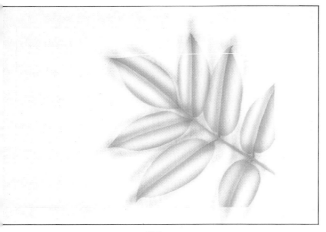

3

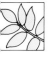

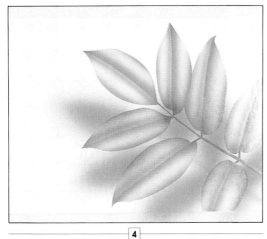

4

Keeping the masking in place over the leaf shapes, spray the whole background area with a light tone of sandy yellow **5**, working evenly across the unsprayed areas of the artboard and the shadow pattern. Build up the color gradually to form an overall warm tone suggesting a sunlit wall behind the leaf spray. When complete, remove all the remaining masking film **6**.

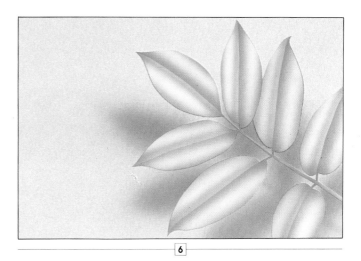

6

HARD MASKING
WITH FILM

Draw the image in outline and cover the surface of the artboard with masking film **1**. Remove the small sections of masking film from the cast shadows formed by overlapping leaves. Spray with an even tone of dark green to create areas of flat color **2**.

Remove the section of masking film from the lower half of each leaf below the line of the leaf vein. Spray freehand with dark green to create soft lines of color along the edges of the mask sections still in place **3**. Allow the color to dry. Remove the remaining masking film from within the shape of each leaf and from the main stem, leaving the background masking in place **4**.

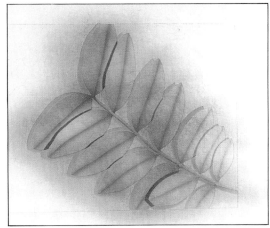

5

6

When the color is dry, remove the masking film from the background of the image, leaving the mask sections on the leaves and stem in place. Spray evenly across the background area with a warm, pale tone of yellow, overspraying the shadow areas **7**. Allow the color to dry and remove all remaining masking from the leaf spray and from the border of the image **8**.

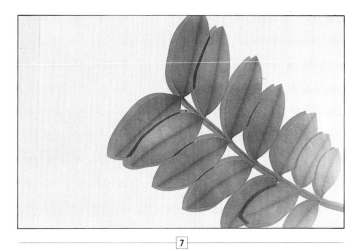

7

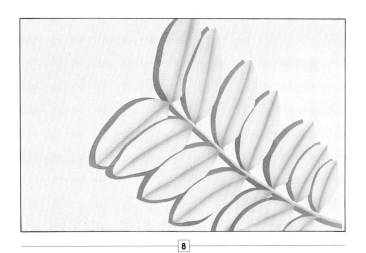

8

ray graded tones of mid-green over the whole surface of each af, building up the color density slightly at the leaf base and where e color overlaps the central vein **5**. Allow the color to dry and place film masking on the leaf shapes. Remove masking from the ard-edged shadow areas behind leaves and stem. Spray all xposed areas with a flat, dense tone of sepia **6**.

LOOSE MASKING
WITH ACETATE

1

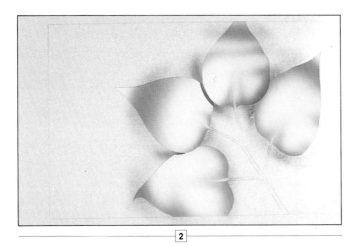

2

Draw the image in outline and cover with masking film. Lift masking from the small areas of cast shadow between overlapping leaves; spray with dark green **1**. Unmask all the leaf shapes and model the surfaces with graded tones of dark green as shown **2**.

Unmask the main stem and spray dark green shadow above the leaf joints. Allow the color to dry completely on leaves and stem. Overspray each leaf shape with mid-green **3**. Trace the outlines of the leaf spray on a piece of acetate. Move the acetate to a separate surface and cut out the leaf shapes with a sharp scalpel, leaving a border all around the image area **4**.

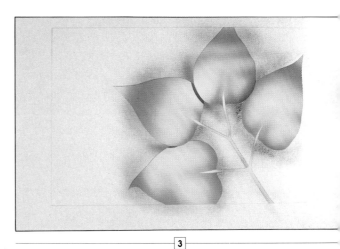

3

4

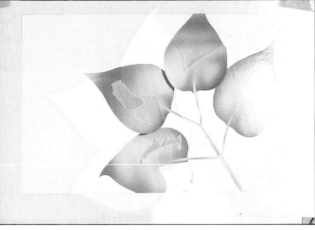

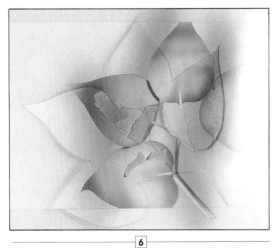

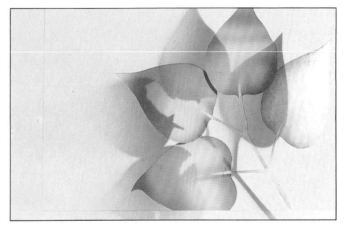

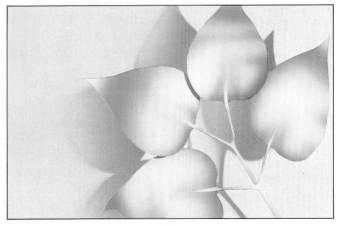

Remove the acetate mask, but keep the masking film in place over the green leaf shapes. Spray the background of the image with a warm, pale tone of yellow, overspraying the sepia shadows as well as the remaining white areas of artboard **7**. Allow the color to dry; then carefully remove the masking film from the leaves and from the border of the image to show the final result **8**.

<div style="text-align:center">**5**</div>

<div style="text-align:center">**6**</div>

<div style="text-align:center">**7**</div>

<div style="text-align:center">**8**</div>

move background masking from the artwork and remask the rayed leaves with masking film. Lay the acetate mask over the ginal image, positioned to the left of the leaf spray and over- oping the shapes **5**. Spray graded tones of sepia into the itout shapes of the acetate mask as shown, forming shadow areas ound the green leaves fading off to the left-hand edges **6**.

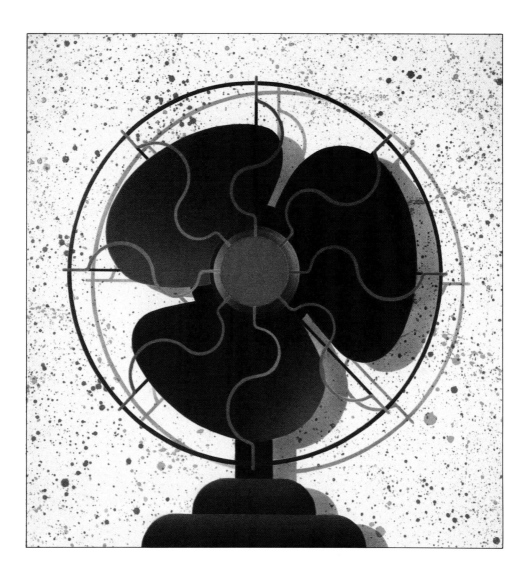

FAN ERNST MEIR

The graphic treatment of this subject produces a strong image relying on silhouette to describe the form. The blades of the fan are minimally graded from black to gray: the clean outlines are reinforced by the cast shadow on the textured background.

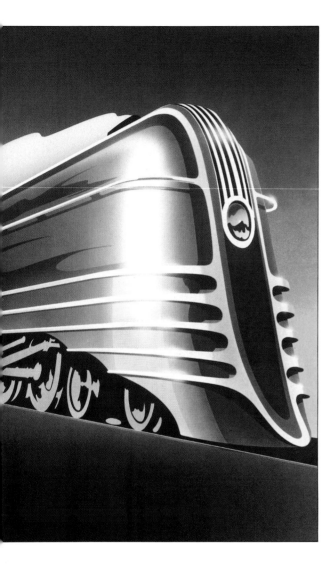

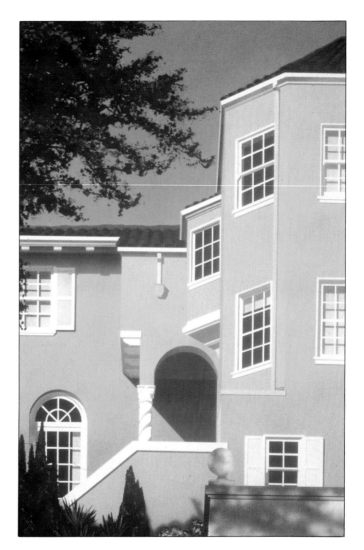

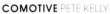

COMOTIVE PETE KELLY
ɔdow detail is boldly presented here to model the streamlined
ɔpe of the locomotive. The patterns of light and shadow on the
ɟeels and engine body are stylized, the contrasts emphasized,
t the rendering has its own sense of powerful realism.

VILLA SAN MARCO DAVID HOLMES
A sunny effect is created by the warm color of the house front, but
the shadow detail gives depth and definition to the view. The
hard angle of the shadow under the arch contrasts with the
dappled foreground shading caused by the tree branches.

ALTERNATIVE MASKING METHODS

SHADOW EFFECTS:
USING AN OPAQUE MEDIUM

With a transparent medium such as watercolor or ink, shadow areas can be laid in first and lightly glazed over with color. The layering of spray enhances the depth of the shadows showing through the color. When using gouache, which is an opaque medium, only an initial spraying produces an effect of graded tone: if the color is further built up it becomes progressively flatter and underlying detail is gradually disguised or entirely obliterated.

Two particular techniques required when working with gouache are demonstrated here, in forming an image which includes both volumetric and cast shadows. The distinctly darker tones of the color of each object have to be mixed in the palette and sprayed over the original color, unlike with watercolor in which successive sprayings increase the tonal density. Between stages, masks have to be replaced as the color areas must be kept separate to produce the required final effect, whereas with watercolor, working dark to light, it is often possible to leave sprayed areas exposed since the subsequent color will have little effect on the darker tone already in place (compare the exercise on pages 8-9).

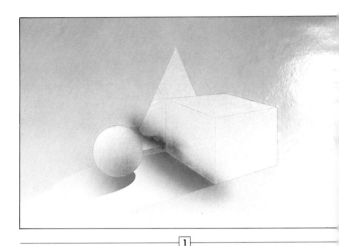

1

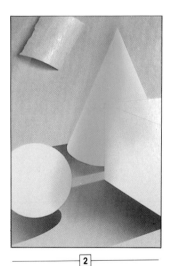

2

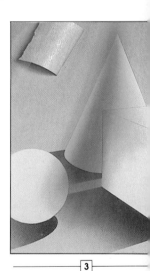

3

Draw the objects and their cast shadows in outline. Apply mask film and cut the outlines. Remove background masking and spra graded tone of blue. Remask when dry. Spray graded tones of g into the cast shadow areas **1**. When dry, replace the masks. Unm the cone and spray a graded tone of green **2**. Allow to dry c apply a flaring band of darker green shadow as shown **3**.

mask the top plane of the cube and spray a lightly graded tone of
d **4**. Remove masking from the right-hand plane with the same
d, spray solid, flat color **5**. Allow to dry and remask the shape. Lift
e masking from the left-hand side of the cube. Mix a red-brown
lor, a few shades darker than the previous red, and spray the
posed plane **6**.

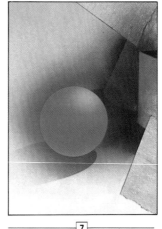

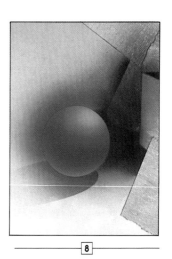

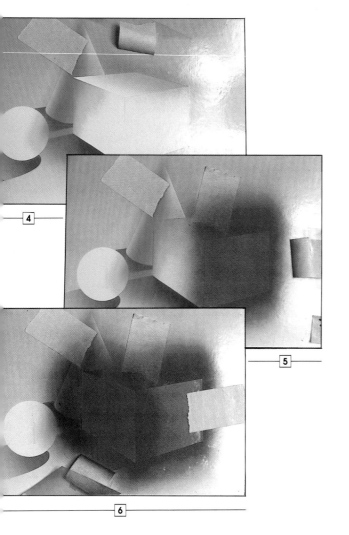

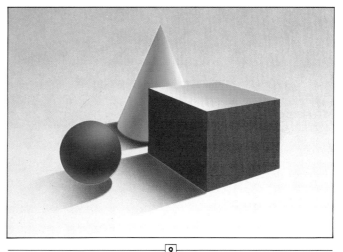

With other masking back in place, remove the mask from the sphere
and spray with a graded tone of blue **7**, varying the density of spray
to create highlight areas. Mix blue with black and spray dark
shadow around the lower curve of the sphere, keeping the edge
light-toned **8**. When the color is dry, remove all remaining masking
to reveal the completed image **9**.

FABRIC FOLDS: FREEHAND MODELING

This project takes advantage of the transparency of watercolor to model the shadow detail of fluidly curving fabric folds by layering dark, mid- and light tones in successive stages. The basic forms are laid in by applying dark tone against hard masked edges: loose acetate masks are used to overspray the heavy tonal detail representing cast shadows. The soft-edged shadows which develop the draped effect are sprayed freehand to provide the subtlety of the tonal modeling.

The gentle gradation of tonal values from dark to light through a range of mid-tones also provides the surface effect of a silky sheen on the fabric. The highlight areas are indivisible from the shadows: they are formed naturally out of the areas which receive no direct application of color. It is the high degree of contrast which suggests the smoothness of the fabric texture, but this is modified by the bands of freehand spraying which indicate at the same time the pliant quality of the material.

The fluidity of the fabric folds is already present in the simple, descriptive lines of the initial drawing, and is dramatically enhanced by the airbrushed color.

1

2

Make a trace drawing of the image showing the main areas of d⌐ tone in the shadowing of the fabric folds ∎. Transfer the outlines artboard and cover with masking film. Remove the sections masking film from the main shadow areas at right. Spray the inn⌐ curve with dark tone graded down the form ∎.

the mask sections leading from the sprayed curve to the base of
the image and to the top left-hand edge of the frame. Spray the
darkest areas of these shapes with soft-edged color **3**. Work across
the drawing on the left-hand side in the same way to lay in a dark
edge along the remaining shadow shape **4**.

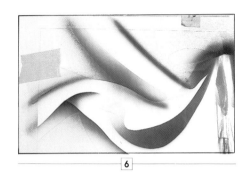

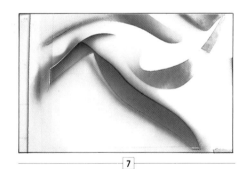

Remove the central section of masking film lying between the
previously sprayed shapes **5**. Model fine lines of shadow across the
upper edges of the main folds in the fabric **6**. Use a loose acetate
mask with cutout shapes based on the original drawing to develop
the dark tones representing cast shadows **7**.

Work across the image again, finally intensifying and extending the areas of darkest tone and grading them to mid-tone where appropriate **8**. When this part of the work is complete, remove all remaining masking film. Allow the color to dry completely and remask the image with clean film **9**.

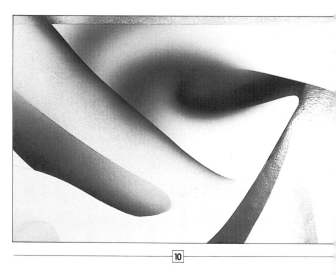

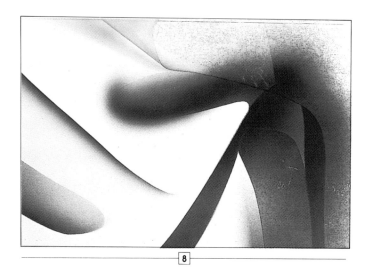

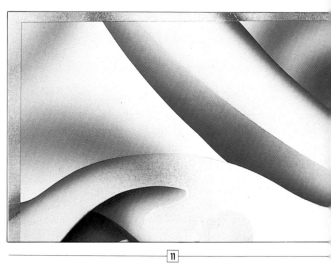

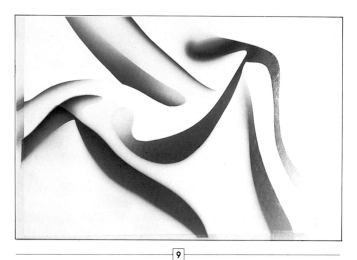

Remove the section of mask above the main shadow area at to right and spray freehand to model the soft-edged fold of the fabr in mid-tone **10**. Work in the same way on the left-hand corner of th image to spray soft bands of tone representing the curving surfac of the fabric behind the central folds **11**.

mask the central section of the image showing the highest curves [of] the fabric folds. Model the tonal gradation in light to mid-tone, [de]veloping the three-dimensional form and the silky sheen of the [sur]face effect **12**. Remove masking from the lower part of the image [an]d spray in the hazy lines of mid-tone **13**.

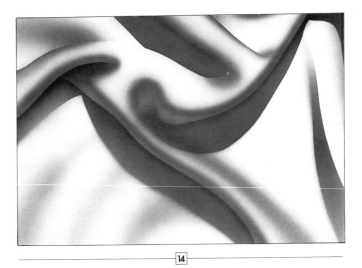

14

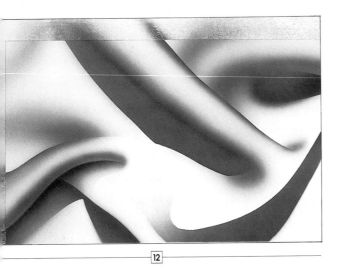

12

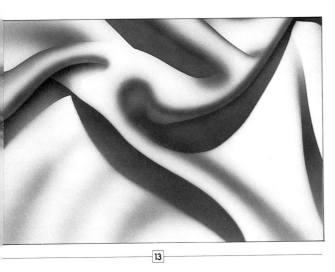

13

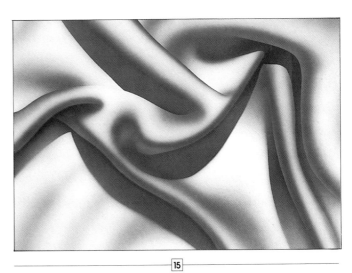

15

With all masking removed from the sprayed areas, leaving a masked border around the edge of the image, work across the fabric with freehand spraying to develop the shadow detail, integrating all the previously sprayed areas **14**. Allow the color to dry and remove the remaining masking film from the final image **15**.

ANGLED LIGHT SOURCES: ATMOSPHERIC SHADOW

Harsh, angled lighting creates a mood in an image, an effect commonly exploited in lighting for theater and films. Three different angles of light are described in these projects, applied to the same basic drawing of a face. This allows a direct comparison of the atmospheric element of the finished image in each case. All the portraits are executed in monochrome to emphasize the shadow patterns and clearly demonstrate the distribution of the airbrushed tones in each example.

The first full sequence of pictures represents a face lit from below; the image is built gradually, working from dark to light across the whole image and within the individual sections. This way of lighting a face creates a rather sinister effect, throwing the features into powerful relief.

The second portrait shows strong lighting from the side: the contrasts here are softened and the shadows less evenly disposed. In the final image, lit from above, there is more overall detail in the modeling of the face. The effect is still dramatic and atmospheric, but less stark than that created by the underlighting of the first portrait, which seems to bleach out such detail.

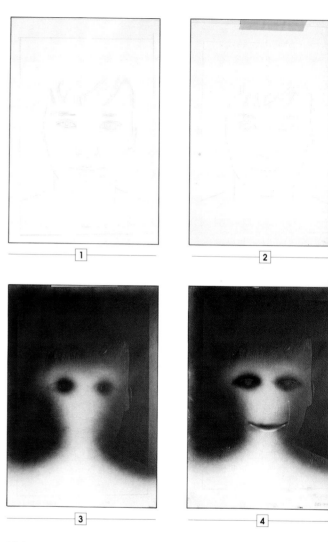

Make a basic outline drawing of the face on tracing paper ◼. Transfer the image to artboard and cover with masking film ◪. Remove the masking from the background and the darkest shadow areas in the hair and eyes. Spray with black, forming a very subtle tonal gradation behind the head **3**. Unmask the line of shadow on the lips and spray with black **4**.

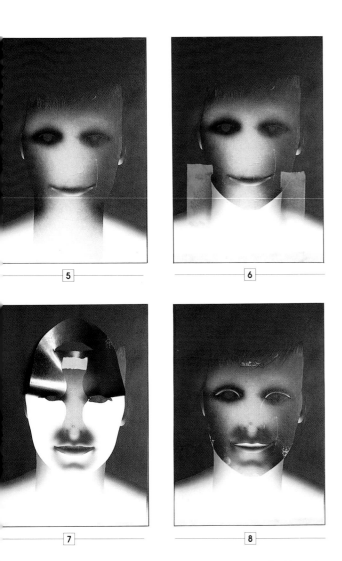

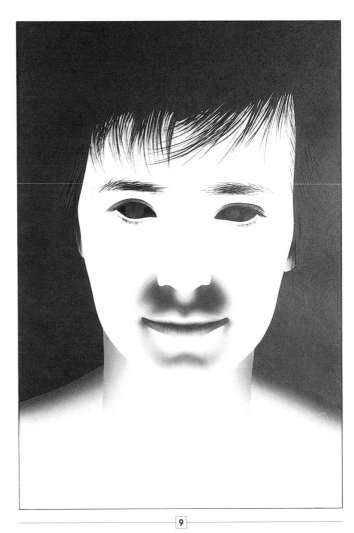

ft the mask sections from the shoulders and spray graded tone to ‌hadow the outlines **5**. Remask these areas when dry **6** and spray ‌raded tone on the neck below the chin. Turn back the mask from ‌ne lower part of the face and spray shadows on the curve of the ‌hin and below the nose **7**. Replace the mask when the color is dry ‌nd apply mid-toned detail to the mouth, eyelids and ears **8**.

Lift the mask sections from each side of the nose and spray a faint haze of gray. Remove the remaining masks: use a fine paintbrush and black paint to develop the detail of strands of hair falling over the forehead. Work in the same way to draw in the individual hairs of eyebrows and eyelashes **9**. Use fine but bold strokes to create this linear texture.

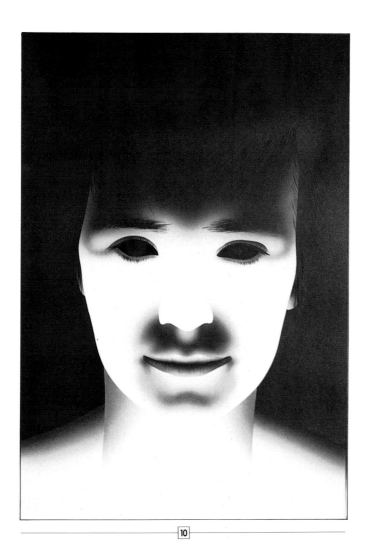

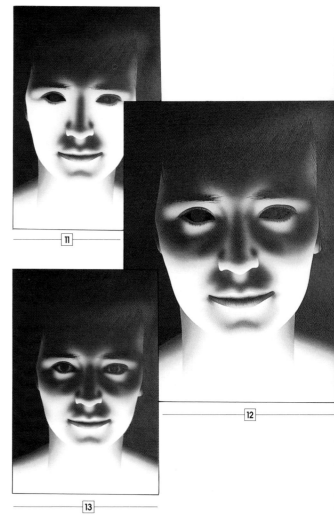

Starting work at the top of the head, spray freehand with black to lay in dark shadow above the eyebrows, overspraying the detail in the hairline. Holding the airbrush close to the surface to control the width of the spray, lay in lines of mid-toned shadow curving from the forehead down to the outer corners of the eyes **10**. Check the balance of tone against the detail in the lower face.

Gradually extend the areas of deep shadow down the line of th nose, emphasizing the curve of the nostrils but leaving a broa highlight on the lower edge **11**. Lay in the arcs of shadow below th eyes **12**. Introduce more subtle modeling in the cheeks and chi maintaining the heavy contrast of light and shade. Unmask th whites of the eyes and shade lightly **13**.

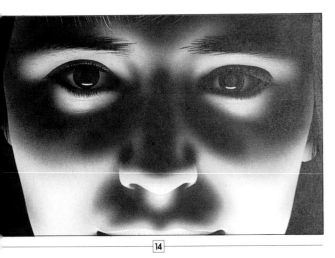

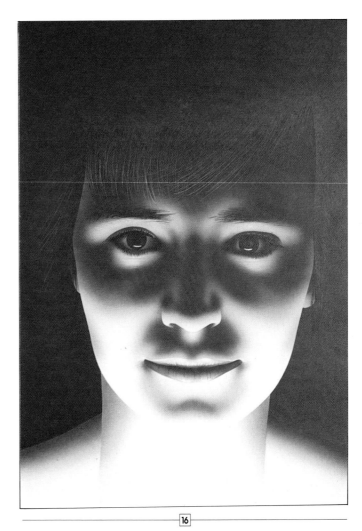

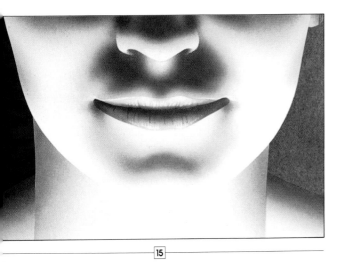

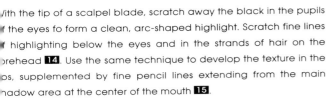

With the tip of a scalpel blade, scratch away the black in the pupils of the eyes fo form a clean, arc-shaped highlight. Scratch fine lines of highlighting below the eyes and in the strands of hair on the forehead **14**. Use the same technique to develop the texture in the ?ps, supplemented by fine pencil lines extending from the main ?hadow area at the center of the mouth **15**.

In the completed image **16**, the light cast from below highlights the lower area of the face; note how the point of the chin is barely defined against the neck. The heavy shadows in the upper part of the face are extremely dense: the dark and mid-tones are directly counterpointed by the much smaller areas of highlighting in this section of the image, giving a strongly modeled effect.

ATMOSPHERIC SHADOW

LIGHTING FROM ONE SIDE

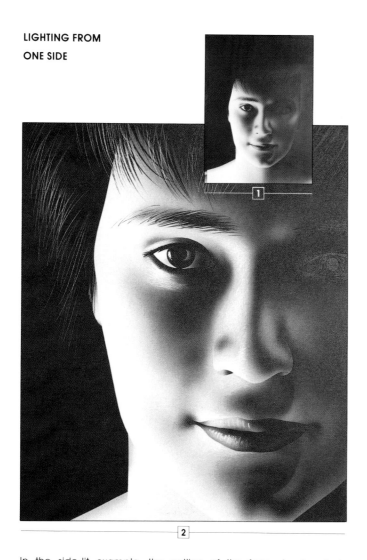

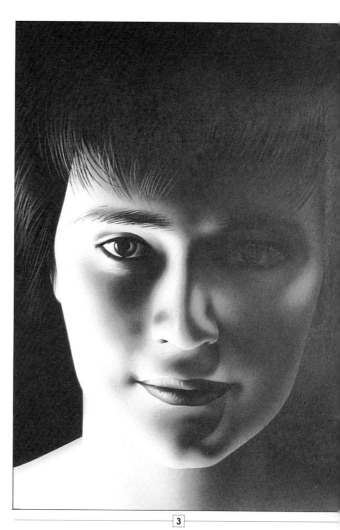

In the side-lit example, the outline of the face stands crisply delineated against the background; the heaviest areas of shadow are in the eye sockets, traveling down on either side of the nose, but the mid-tones are more subtly developed **1**. Highlighting in the eyes, nose and hair is created in the same way as the first example **2** to achieve an effect of subtle contrast.

The degree of contrast in the final image **3** extends across the same tonal range as in the face lit from below, but is modulated by the increased areas of mid-tone. The airbrushing technique follows the same pattern of establishing hard-edged shadows first and overspraying freehand. This rendering produces an impressive but more sympathetic portrait.

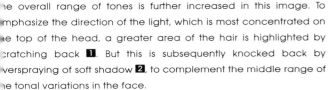

1

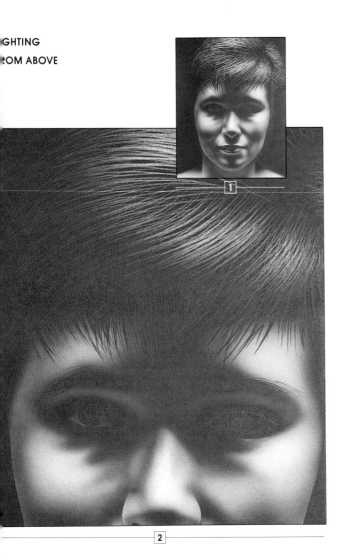

2

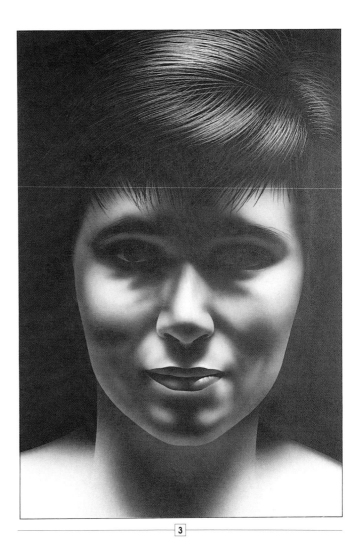

3

he overall range of tones is further increased in this image. To mphasize the direction of the light, which is most concentrated on e top of the head, a greater area of the hair is highlighted by cratching back **1**. But this is subsequently knocked back by verspraying of soft shadow **2**, to complement the middle range of e tonal variations in the face.

The basic pattern of light and shade in this example **3** is the reverse of that described in the first image, in that the brow and cheekbones are highlighted and more of the shadow falls in the lower part of the face. It is, however, also a more naturalistic effect because of the broader distribution of tones, with the modeling of the face creating a complex visual texture

ATMOSPHERIC SHADOW

STYLIZED SHADOW EFFECT: HARD-EDGED PATTERNS

The basic method of producing a stylized graphic image consists of identifying realistic detail and exaggerating its effect. This project follows directly from the previous portraits in that the underlying structure of the drawing is the same. But where before the shadows were soft-edged and gradated to create a coherent surface, the initial drawing here puts hard edges around the variations of tone. The form, volume and texture of the portrait are broken into a map-like linear pattern which is reinterpreted as solid blocks of color and tone, with minimal shading. The portrait can justifiably be regarded as a generally accurate representation: it is recognizable as the same face which appeared in the monochrome renderings, but the artist has chosen to develop the image in a different style.

The technique is typical of airbrush work in watercolor. The shadows are sprayed in a limited tonal range: color is applied over the tonal modeling, with the transparency of the medium preserving the previously established form of the image. The restricted color range, based on naturalistic colors, is in keeping with the bold style of the graphic rendering.

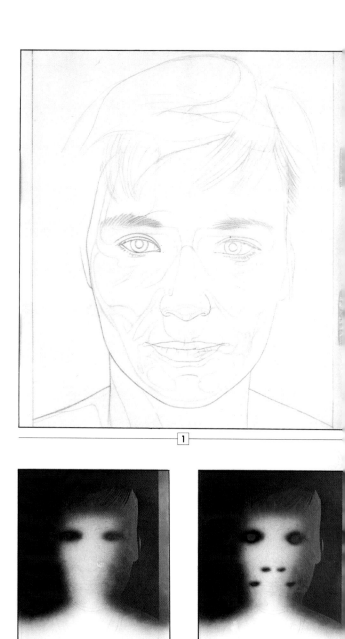

1

2

3

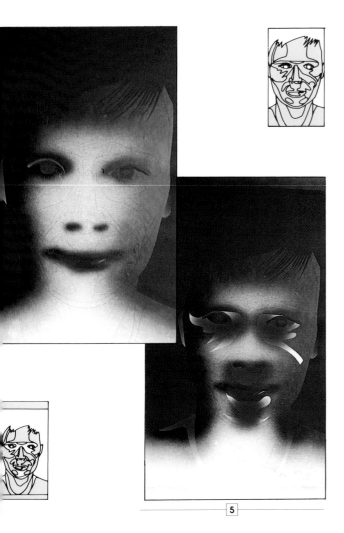

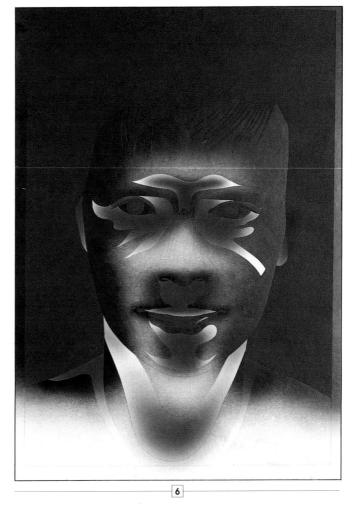

Make a detailed outline drawing of the face, defining the main features and all the areas of highlight and shadow **1**. Transfer the drawing to artboard and cover the image area with masking film. Remove masking from the areas of darkest shadow in the background, across the hairline and around the folds of the eyelids. Spray with black **2**. Apply dark sepia shadow to the eyes, nose and mouth surrounding the black areas previously sprayed **3**. Continue to lift the mask sections in sequence to model sepia tone forming shadow areas around the eyes, ears and mouth **4**. Extend the shadows gradually outward from the main features, following the outlines in the drawing which indicate the strongest areas of shadow in the face **5**. Unmask the central shadow area leading from each side of the face down to the base of the neck and spray with graded sepia tone **6**.

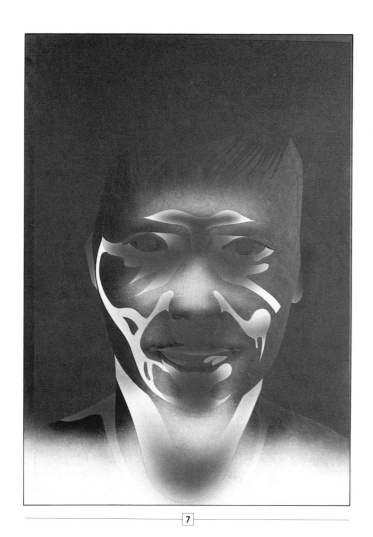

7

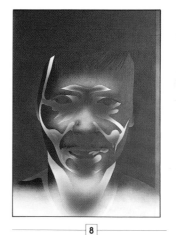

8

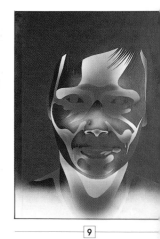

9

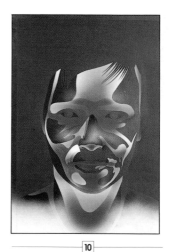

10

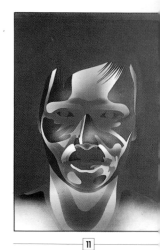

11

Remove masking from the shapes extending around nose and cheek and spray with sepia as before. Unmask the full shape of the lips and apply red over the shadowing on the upper lip and across the partly-shadowed lower lip **7**. Unmask sections on the face representing mid-toned shadow and continue to model the forms with graded tones of sepia **8**, gradually exposing broader areas of the forehead and neck **9**. Continue to work in the same way across

areas of the face on the left-hand side of the nose and across th chin **10**. At this stage, the sections of the painting which show blac in the photograph are those which are still masked and will becom highlighted areas. Remove masking from the remaining mid-tone areas in the nose and chin and work lightly across the whole imag with the sepia spray to adjust the balance of tones, strengthenin the tonal values **11**.

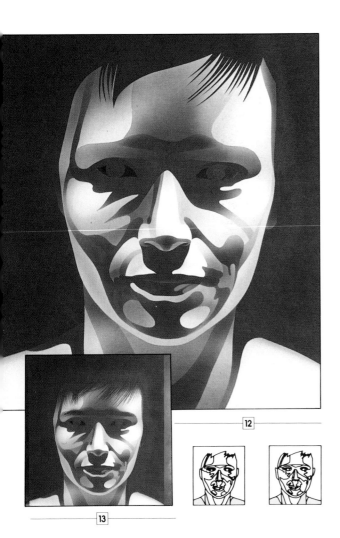

12

13

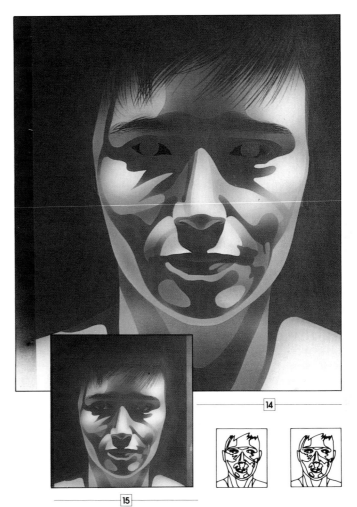

14

15

Remove the remaining masking film from all areas of the face, except the eyes, and from the neck and shoulders. Apply a very fine spray of sepia at the edges of the shapes, grading into white, to model the palest areas of tone and the highlights **12**. Use fine brushwork to draw in the eyebrows and strands of hair over the forehead and ears, softening the linear effect by applying dark tone sprayed with the airbrush **13**.

Recharge the airbrush with a warm red-brown flesh tone. Spray lightly over the whole area of the face and neck, then gradually overspray around the areas of dark shadow to build up the strength of the flesh tones over the mid-toned shadows **14**, maintaining highlight areas for contrast. Unmask the whites of the eyes and spray a blue-gray tone from the corners to achieve the correct balance of tone with the surrounding shadow areas **15**.

HARD-EDGED PATTERNS

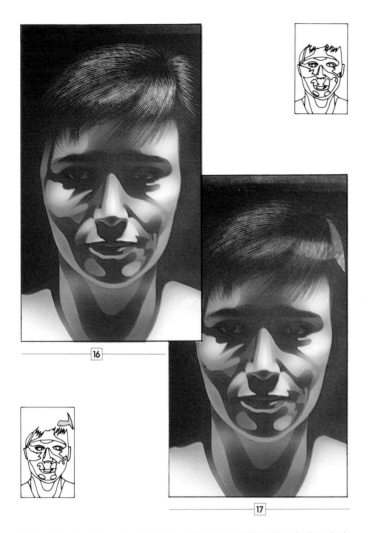

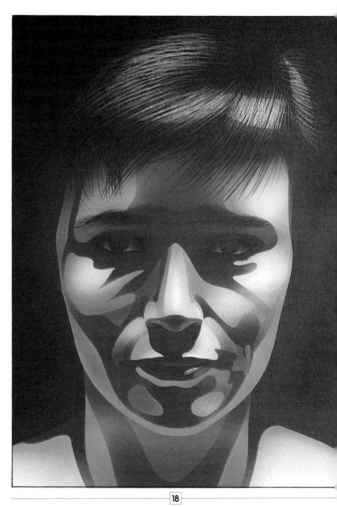

Using the tip of a scalpel blade, scratch back fine lines in the dark color of the hair, producing a highlighted effect which emphasizes the angle of illumination on the whole head **16**. Using a loose mask cut from paper or acetate, apply a fine spray of opaque white to form a pattern of hard-edged shapes across the strands of hair, giving it a stylized form corresponding to the pattern of light and shade in the flesh tones **17**.

When the airbrushing is complete, remove the remaining masking film from around the border of the artboard to produce the clear edged final image **18**. The extreme range of tonal contrast and hard-edged modeling of the shadows create a strong, sharp portrait which shows the basic appearance and character of the subject, yet creates a very different atmosphere from that which a conventional portrait would provide.

VARIETY BRIAN JAMES

A homage to the atmospheric lighting effects of the black-and-white movie era is neatly encapsulated in the folded paper emerging from the raincoat pocket, offset by the rippling light and shade in the sepia tones of the coat fabric.

COLOR IN SHADOW: COLOR CONTRASTS

Shadows are generally considered in terms of their tonal values and often represented as a darker tone of a base color or as a gray or black cast modeled into an otherwise fairly flat color area. Introducing color to the shadow area itself brings into play the mutual effects of similar or opposite colors. Color is an enlivening factor which can be employed to enhance the graphic presentation of an image while maintaining the basic impressions of a rendering describing three-dimensional volume and spatial relationships.

These examples demonstrate two standard principles of color interaction: the different values of warm and cool colors and the contrast obtained by juxtaposing opposite colors. Color contrasts can be used in the same ways as tonal variations to model form and create pictorial space. This sometimes opposes expected effects: for example, in the rendering of the cube on a blue ground under red light, the shadow is effective not because it is dark, but because its color is cold against the surrounding warm hues. Solid blue shadow on a yellow ground works by the principle of graphic contrast in colors which are strongly contrasting.

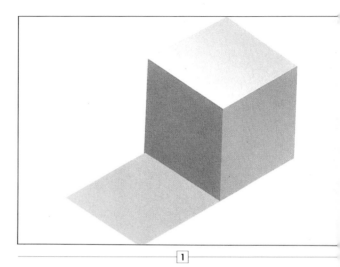

1

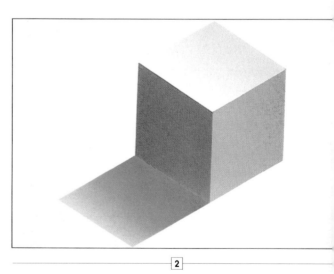

2

The first example **1** shows the effect of white light on a neutral obje[ct] placed within a white background. This sets the pattern to which th[e] other examples relate. The shadow is presented flatly in neutral gr[ay.] A graded tone of blue in the shadow **2** is a graphic device whic[h] suggests by contrast a warmer quality of light.

4

e warm/cool contrast is further developed to show the cube on a
ue ground illuminated by red light **3**. The cold blue shadow
cedes, while the warm pink of the upper plane enhances the
amatically three-dimensional effect. A similar flood of warm light
er a white ground creates a softer variation **4**.

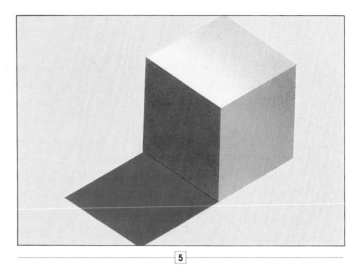

| 5 |

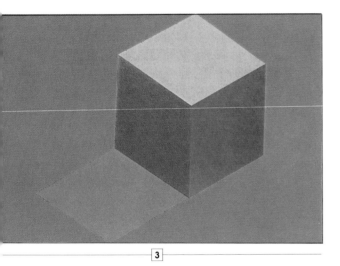

| 3 |

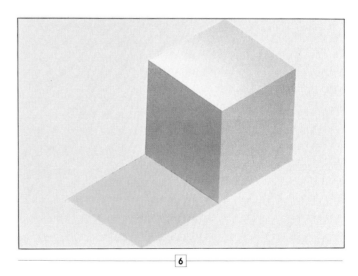

| 6 |

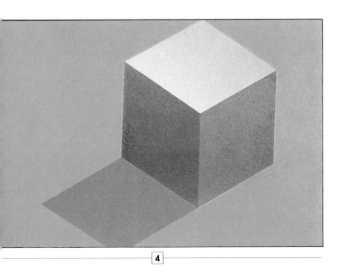

| 4 |

These two examples show the graphic effect of using pure color in
shadow. Complementary (opposite) colors, such as the rich blue
against a pale yellow ground **5**, emphasize the shadow area. A
darker tone of yellow **6** colorfully creates the cast shadow effect
without dramatizing the image.

COLOR CONTRASTS

CAST SHADOWS FROM TRANSPARENT OBJECTS

The cast shadow of a transparent object has its own quality of transparency and forms a very subtle echo of the overall form. The object is not blocking the light to form a solid shadow, but transmitting a low level of light which retraces the tonal and color gradation used to define the original volume of, in these examples, the wine glass or the bottle.

The wine glass is originally executed in monochrome to imitate the effect of clear, colorless glass. The tonal contrasts are quite strongly developed, as conventionally applied to describe a material which is both transparent and reflective. The cast shadow, however, is a mere suggestion of the elements which make up the glass – the bowl, stem and base – indicated by minimal variations in tone.

The shadow of the green glass bottle has a degree of luminosity caused by the rich hue of the material. The general pattern of light and shade in the main image is repeated in the shadow, laid in with faint gray tones, and overlaid with the translucent color. The color quality is subtly different so that the shadow does not compete with the bottle but emphasizes the ground plane.

The shadow of the wine glass **1** consists of three main elements: ca shadows from the rim, stem and bowl. The base of the glass protected with masking film and a fine edge of dark shadow sprayed around the right-hand side of the base **2**. The dark line shadow representing the stem of the glass is applied freehan keeping the airbrush close to the surface. The line of color allowed to dry before the soft wings of the shadow cast by the bo of the glass are sprayed in on either side of the line **3**.

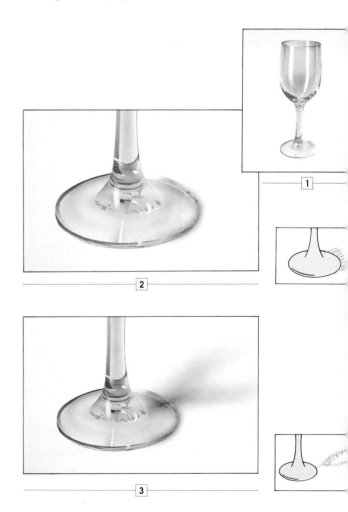

re are two basic stages of spraying cast shadow from the base of completed bottle ▮ to reproduce the translucent color effect. soft gray lines of the shadow are sprayed from inside the shape he bottle, merging to echo the overall form indistinctly on the und plane ▮. Over the gray tone, a soft haze of green is laid into shadow area, lightening slightly where it meets the contour of the t-hand side of the bottle ▮ so that this stands out clearly in front he shadow ▮.

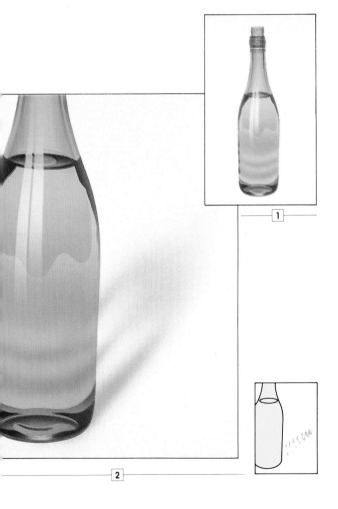

TELEGRAPH POLES: PERSPECTIVE EFFECT

The image of telegraph poles receding into the distance provides a basic demonstration of the perspective effect of the convergence of parallel lines stretching toward the horizon. The first drawing in this sequence shows the layout of the simple perspective: the poles diminish in size toward the horizon and appear closer together as they recede.

Plotting of the shadows on the ground plane emphasizes the effect of distance, but these must be located in the correct relationship to the poles by reference to a fixed point of illumination. The second and third drawings of this sequence show how the shadows are positioned on lines passing directly from the light source (the sun) through reference points on the poles; the angle and length of each shadow are established by means of a line on the ground plane related to the height of the sun above the horizon.

These drawings are shown in two colors to clarify the procedure: for the airbrush work, the drawing is outlined by the normal practice of transferring faint guidelines to the artboard surface. The airbrushing is executed in watercolor, working light-over-dark.

1

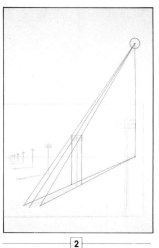

2

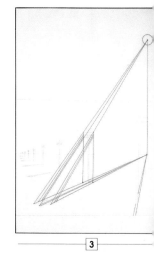

3

Draw converging lines to the horizon and locate the vertical po between these lines **1**. Position the sun outside the frame of t drawing and drop a vertical to the horizon line. Draw lines passi through the top of the telegraph pole onto the ground plane a from the horizon point below the sun to intersect these lines **2**. P the full shadow of each pole in this way **3**.

ply masking film to the full image area and cut the outlines of ch telegraph pole and its corresponding shadow. Remove the os of masking film from the poles and spray with a flat tone of oia **4**. The method of spraying produces a simple silhouetted ape without attempting to develop realistic form, as shown in the tail picture **5**.

Remove the masking film from within the cut outlines of the shadow shapes. Spray each shadow with a mid-tone of sepia **6**, grading the color so that the heaviest tone is at the base of the pole **7**, lightening as it passes along the linear shape toward the far end of the shadow. Make sure that the shadow color remains lighter than the flat tone originally sprayed on the pole.

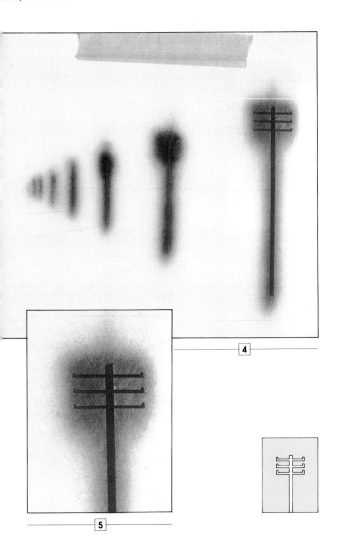

4

5

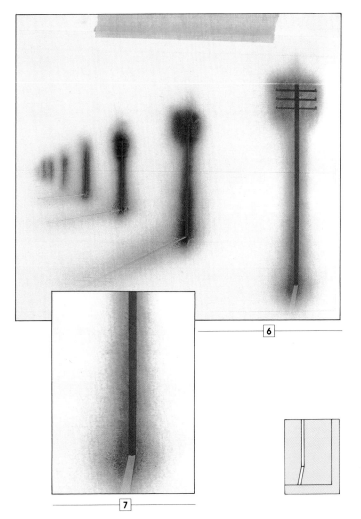

6

7

Cut the masking film along the line of the horizon and lift the top section. Spray a graded tone of blue across the sky area, lightening on the horizon line **8**. Because of the transparency of the watercolor, the faint glaze of blue does not affect the overall tone of the top of the telegraph pole where the colors are overlaid **9**.

Remove the mask from the lower section of the image and spray a pale yellow ocher tone, strengthening toward the base of the picture **10**. Allow the color to dry completely. Lightly trace the lines of the wires linking the poles, using a fine, sharp pencil. To complete the image, draw the shadows of the wires in the same way on the ground plane **11**.

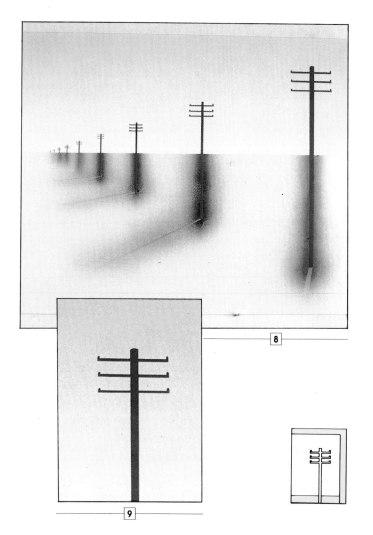

8

9

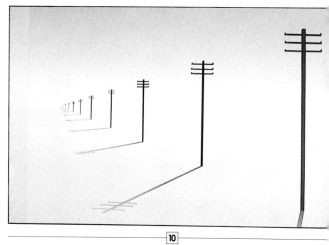

10

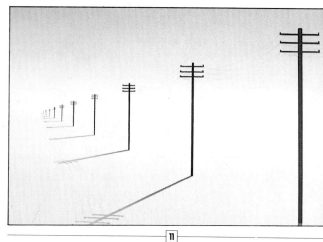

11

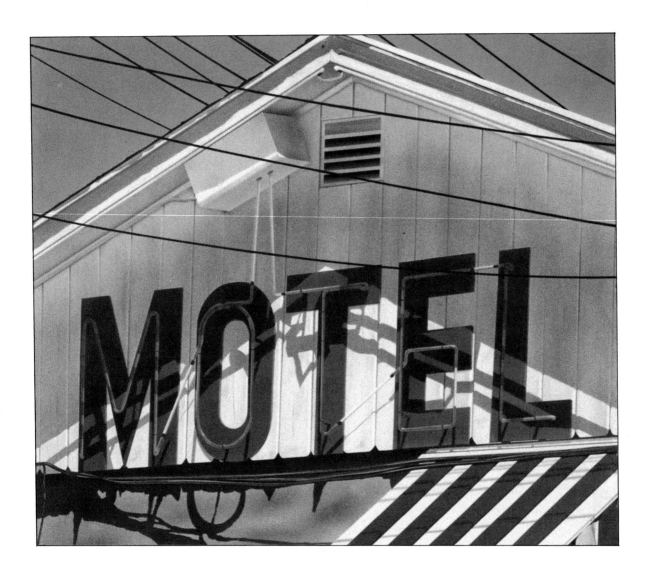

MOTEL BRIAN JAMES
Layering of linear patterns produces a striking image in which actual and shadow forms create a complex network of information. The shadows enhance the crispness of the restricted color range, evoking a strong atmosphere of time and place.

PROJECT: COMBINED SHADOW EFFECTS

The following pages show the progressive stages of an image specially designed to demonstrate a varied combination of volumetric and cast shadow effects. It consists of a number of abstract shapes assembled to form a "face." This allows the artist to introduce a range of colors, tones and textures in a non-realistic context, but each shape is considered and rendered three-dimensionally. In airbrushing the area of shadow, both film masking and loose masks have been used, as well as freehand spraying, to introduce hard and soft edges.

The whole image is given a *trompe l'oeil* framework in the rendering of a sheet of paper on which the image is painted. Three corners of the paper are apparently pinned to the background; the fourth is turned back. A cast shadow locates the edges of the paper. The trick effect of the image is, however, given a new ambiguity by the fact that certain shapes break the edges of the "paper," reminding the viewer that the whole design is a clever illusion. Its success lies in the bold treatment of each different area and the distinct impression of three-dimensionality established by the positioning of the shadow areas.

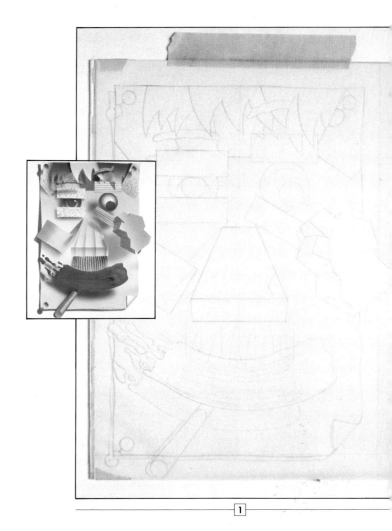

1

Refer to page 61 for a version of the final image which can traced off and scaled up to the required size. Include in the in drawing the outlines of every shape of a different color which require separate masking, but do not trace all the textural de Transfer the image to artboard by inserting a sheet of transfer pa or by rubbing graphite over the back of the original trace **1**. Co the image area with masking film.

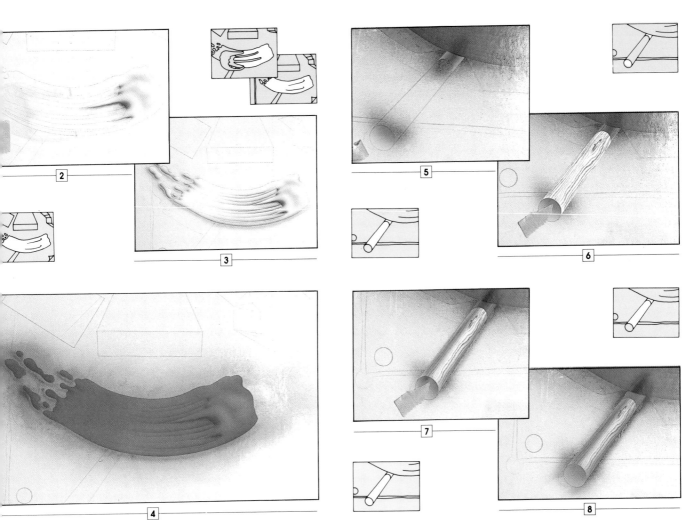

it the masking on the brushstroke forming the shape of the "mouth" d peel back the right-hand section. Spray burnt sienna against e edges of the mask **2**. Continue to work across the shape laying fine lines of graded tone, gradually removing the masking film m the shadow lines to model the forms **3**. Allow the color to dry. charge the airbrush with bright red and spray across the whole ea of the brushstroke **4**.

Unmask each end of the cylindrical shape projecting from beneath the lower curve of the brushstroke. Spray graded tones of gray-brown into the small unmasked areas **5**. Unmask the central section of the cylinder and use a fine paintbrush to paint a linear wood-grain pattern in the same color **6**. Overspray bands of mid-tone along the grain **7**. Spray across the whole shape with a fine layer of golden yellow **8**.

Lift the section of masking film covering the slanted rectangle to the left of the "nose" shape. Spray lightly with mid-green across the left-hand side of the rectangle **9**. Allow the color to dry. Spray the right-hand side of the rectangle with yellow, allowing it to overlap the green in a gentle gradation. Use a piece of acetate as a loose mask to apply a hard-edged wedge of gray shadow from the right-hand corner of the rectangle as shown **10**.

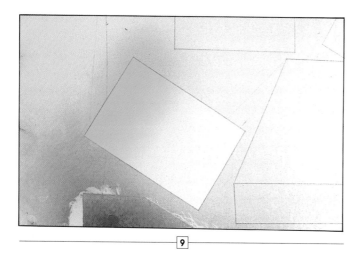

9

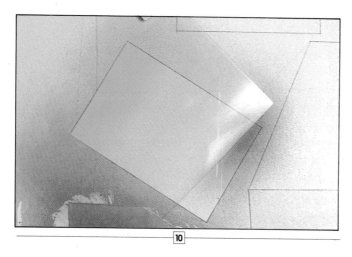

10

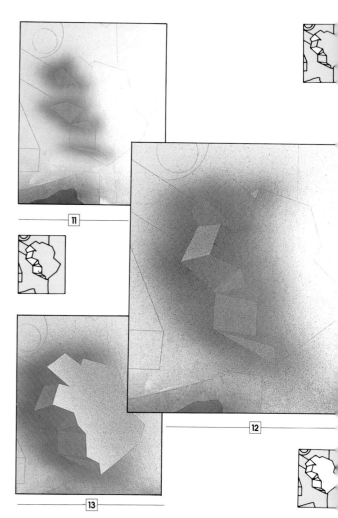

11

12

13

Take off the mask sections from the downward-facing shado planes of the irregular shape at the right of the image. Spray w a soft gray **11**. Unmask the upward-facing planes and spray w lighter gray **12**. Remove the main mask section from within th general outline of the shape. Spray a graded tone of gray rig across the surface, starting with a mid-tone and grading it lighter gray on the left-hand side **13**.

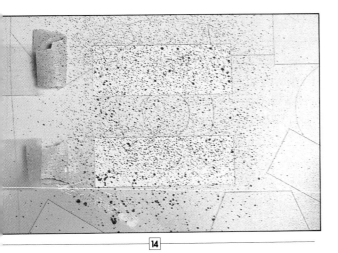

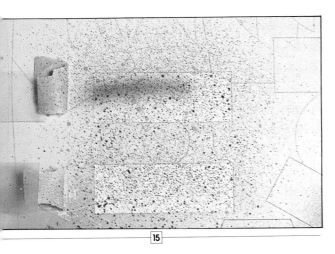

In the rectangle above the right "eye," lift the masks from the shadow points and spray with dark gray tone. Remove the remaining masking from the top half of the rectangle and spray even bands of graded purple, using an acetate loose mask to make hard-edged lines. Unmask the rectangle below the "eye" **16**. Spray narrower bands of purple into this section of the image, following the slantwise direction of the shape **17**.

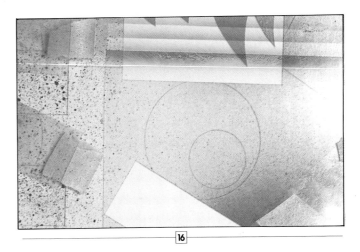

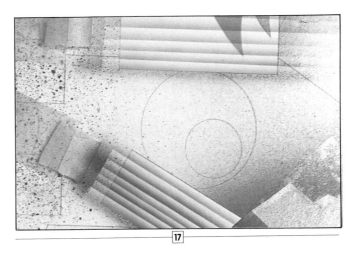

rn back the strips of masking from the horizontal rectangles bove and below the left "eye". Apply a coarsely spattered spray f blue **14**. The spatter effect can be done with a spatter cap if e airbrush has this attachment; otherwise, the same effect is btained by lowering the ratio of paint to air passing through the irbrush. Allow the blue coloring to dry, then overspray with yellow sing the same spatter technique **15**.

COMBINED SHADOW EFFECTS

Replace the masks over the purple-striped rectangles when the color is dry. Unmask the circle at the center of each "eye". Spray with a flat tone of blue **18**. Remove masking from the areas surrounding the blue circles. Spray the right "eye" with blue, forming a circle of graded tone modeling a spherical effect around the central blue circle. On the left "eye," apply the same effect to the visible sections of the shape **19**.

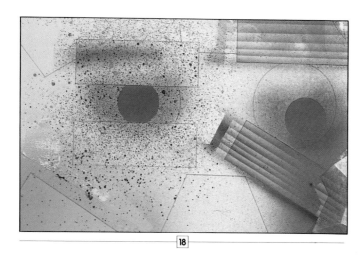

18

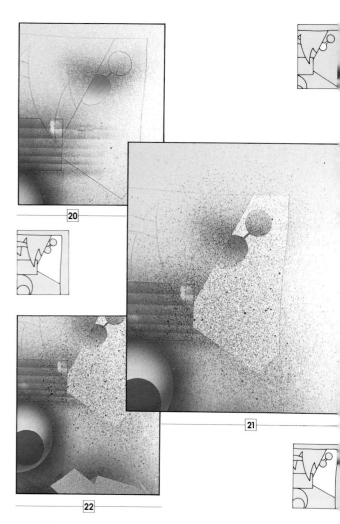

20

21

22

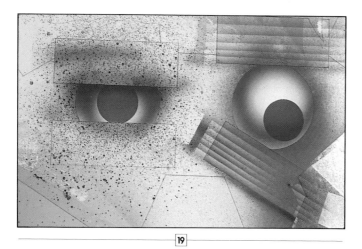

19

Unmask the oval shape forming the shadow of the thumb tack at the top right of the image. Spray with a graded tone of gray **20** Spray the circular shape above it in sepia oversprayed with yellow. Remove masking from the surrounding rectangular area and apply a spattered texture in red, using the same method as in step 14 **21**. When the color is dry, spatter again using dark green **22**. Repeat to color the corresponding shapes at top left.

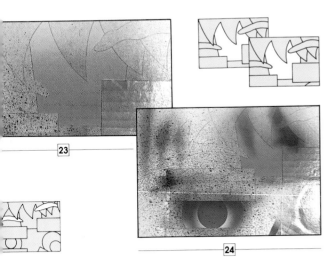

23

24

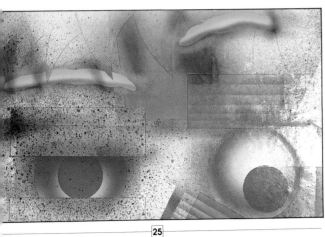

25

Remove masking from the jagged shape of the section of "hair" at top left of the image. Spray with a graded purple-pink and shadow the right-hand edge with a darker tone **26**. Replace the mask when the color is dry. Color the central section at the top of the image in yellow, leaving white highlights at each point. Shadow the right-hand edge as before **27**. Remask when dry and repeat to color the last section in purple-pink **28**.

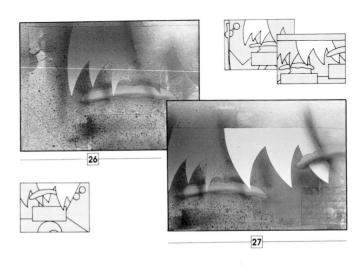

26

27

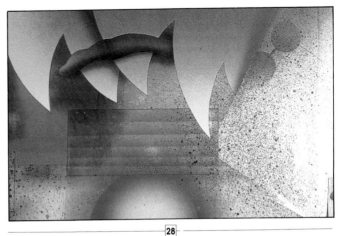

28

…mask the irregular shape between the "hair" and the …yebrows" near the center top of the image. Spray with graded …olor, passing from orange to yellow – spray the orange first, then …verspray the yellow **23**. Allow the color to dry and spray …id-toned gray shadows over the shape as shown **24**. Lift the …asking from the "eyebrows." Spray with black along the lower …dges and lightly shade the interior. Overspray with green **25**.

Lift the rectangular piece of masking film from the base of the "nose" and spray with a very pale tone of light red **29**. Using a clean piece of acetate as a loose mask, spray a vertical line of red-brown shadow down the left-hand side of the rectangle. Move the mask along and spray another line in the same way. Apply a third line **30** and finally a fourth line close to the right-hand edge of the rectangle.

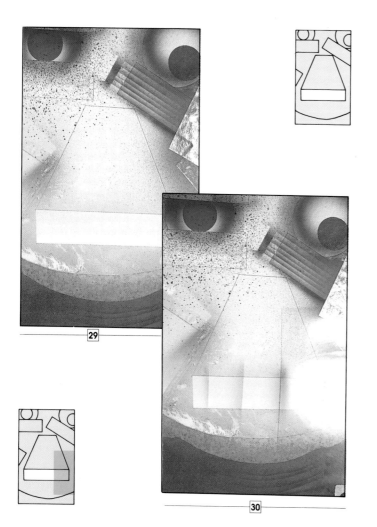

29

30

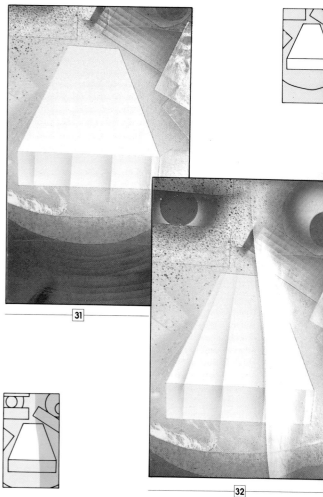

31

32

Remove the masking film from the perspective rectangle abov[e] the previously sprayed rectangular area. Spray the light red ti[nt] as before, grading the color from back to front of the shape **3[1]** but maintaining the pale tone. Again use the edge of a piece [of] acetate as a loose mask to create lines of shadow leading fro[m] the vertical lines and following the perspective effect of th[e] rectangle as shown **32**.

ut sections from a piece of acetate corresponding to the
hapes of the shadows cast by the purple-striped rectangle and
e irregular form at the right-hand side of the image. Using the
cetate masks, loosely held above the surface of the artboard,
pray gray tone onto the upper plane of the "nose," forming
oft-edged shapes **33**. Judge the balance of tone against the
rays in the irregular form.

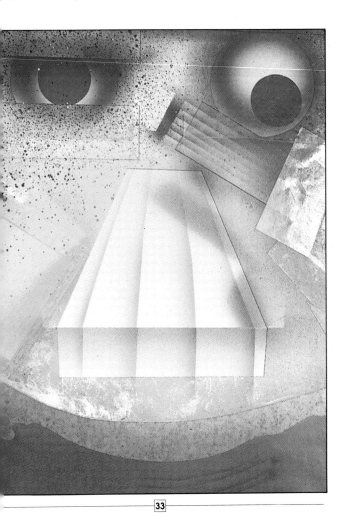

33

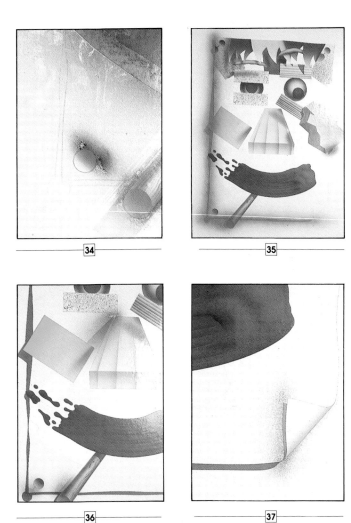

34

35

36

37

Unmask the circular shape in the lower left corner and spray a
sepia tone, oversprayed with yellow **34**. Remove all masking film
and remask with clean film. Cut the lines of the cast shadow on
the left and lower edges of the "paper" rectangle. Spray with gray
35. Unmask the cast shadow of the thumb tack at the lower left
corner and spray with gray **36**. With a lighter tone, spray the
shadow on the folded corner of the paper at the right **37**.

COMBINED SHADOW EFFECTS

Cut the mask around the edges of all the shapes previously sprayed in the top half of the image. Lift the sections of masking film covering areas so far unsprayed. Apply a very pale, warm tone across this entire unmasked area. Repeat the process to expose all the sections in the lower half of the image which have not yet been sprayed. Apply a correspondingly pale tone of green to create a cool balance against the upper half **38**.

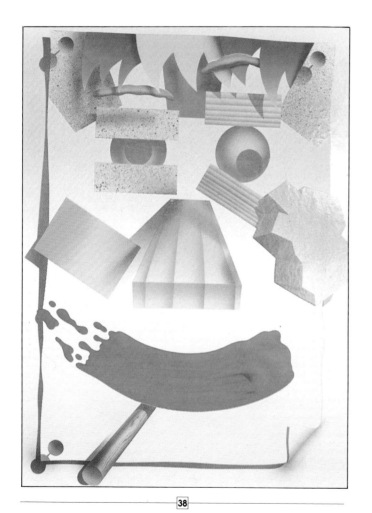

38

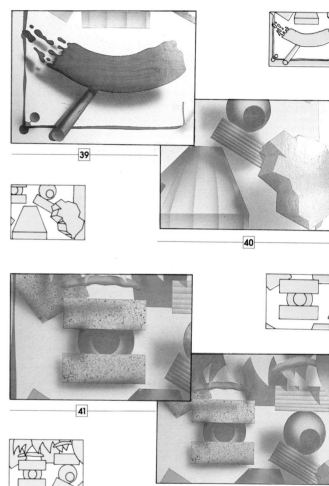

39

40

41

42

Recharge the airbrush with dark gray and spray freehand to create the cast shadow of the "mouth" **39**. Down the right-hand side of the image, apply mid-toned gray to form the cast shadows of the main shapes **40**. Spray in the shadows of the left "eye" and the abstract shape above in the same way **41**. Move across the top of the image, applying cast shadows echoing each of the colored shapes pointing down from the top edge **42**.

...ray fine, slightly curving bands of gray tone vertically from "...ose" to "mouth." Using a brown pastel, draw the lines of the "...oustache", passing in the same direction between the shadow ...nes **43**. As a finishing touch to the center section of the image, ...se a scalpel to scratch back white highlights on the curve of ...ach "eye," making roughly rectangular shapes solid at the top ...nd ragged at the lower edge as shown **44**.

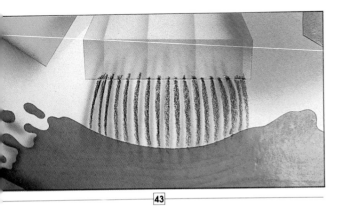

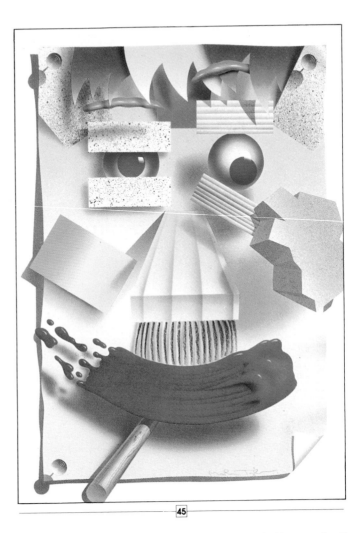

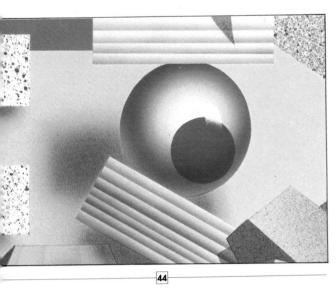

The last details are added to increase the effect of *trompe l'oeil* in the thumb tacks holding the "paper" in place at the top and lower left corners of the image. With the tip of a scalpel blade, inscribe small arc-shaped highlights, like concentric ripples spreading in water, to form the rounded heads of the thumb tacks. Check the image to ensure all details are correct and remove the remaining masking to reveal the finished image **45**.

GLOSSARY

Acetate A transparent film, produced in a variety of weights and thicknesses, used in airbrush work for loose masking and cut stencils.

Acrylics Paints consisting of pigments dispersed in a binding medium of synthetic acrylic resin, available in liquid or paste form.

Artboard A smooth-surfaced support particularly suitable for airbrushing as the surface allows a high degree of finish to graphic work and illustration. It is available in various thicknesses, flexible or rigid.

Artwork A graphic image or illustration of any kind, which may be intended for reproduction.

Bleed 1 A ragged line of color caused by paint penetrating beneath the edge of a mask. **2** The effect of a color which shows through an overlying layer of opaque paint.

Color cup A type of paint reservoir attached to certain types of airbrush; a metal bowl which is an integral part of the tool.

Compressor An electrically-driven mechanism designed to supply a continuous source of air to an airbrush.

Double-action The mechanism of an air-brush which allows paint and air supplies to be separately manipulated by the airbrush user. In independent double-action airbrushes, paint and air can be fed through in variable proportions, enabling the user to adjust the spray quality.

Film masking See Masking film.

Freehand The technique of airbrushing without use of masks.

Gouache A type of paint consisting of pigment in a gum binder and including a filler substance that makes the color opaque. It is a viscous substance and must be diluted with water to a fluid consistency for use in airbrushing.

Grain The surface quality of paper or board resulting from the texture of its constituent fibers and the degree of surface finish.

Ground 1 The surface of the support used for airbrush painting, e.g. paper or board. **2** The overall area of a picture or design on which particular images or graphic elements are arranged.

Hard edge The boundary of a shape or area of color in an airbrush image which forms a clean edge between that and the adjacent section of the image. In air-brushing, this effect is produced by hard masking.

Hard masking The use of masks such as masking film or stiff cardboard which lie flush with the surface of the support and

create sharp outlines to the maske shapes.

Highlights The lightest areas of an imag With transparent media, highlights may b formed by leaving areas unsprayed show the white of the support; usin opaque color, highlights can be spraye in white to enhance tonal contrast create special effects.

Illustration An image accompanying specific text or depicting a given idea action; often intended for reproduction printed works.

Ink A liquid medium for drawing an painting, available in black and a rang of colors; ink is categorized as a trans parent medium.

Internal atomization The process b which medium and air supply are brough together within the nozzle of an airbrush t produce the fine atomized spray of color.

Keyline An outline drawing establishing the area of an image and the structure c its component parts.

Knock back To reduce highlights or othe light areas of an image, subduing the overall tonal contrast, by spraying ove white areas and pale tones.

Loose masking The use of materials suc as paper, cardboard, plastic templates etc. as masks for airbrush work, which d not adhere to the surface of the suppor and can be lifted or repositioned according to the effect required. 3-D

ojects can also be used for particular
fects of shape and texture.

ask Any material or object placed in the
ath of airbrush spray to prevent the spray
om falling on the surface of the sup-
ort. *See* Hard masking, Loose masking,
asking film, Soft masking.

asking film A flexible, self-adhesive
ansparent plastic film laid over a sup-
ort to act as a mask. The material
dheres to the surface of the support, but
e quality of the adhesive allows it to be
ed cleanly without damage to the
derlying surface. This is the most precise
asking material for airbrush work.

edium The substance used for creating
coloring an image, e.g. paint or ink. *See*
rylics, Gouache, Ink, Watercolor.

odeling The method of using tone and
olor to render a two-dimensional image
th an impression of three-dimensional
lidity.

paque medium A paint capable of
oncealing surface marks, such as lines of
drawing or previous layers of paint. This is
ue to a filler in the paint which makes it
nd to dry to a flat, even finish of solid
olor. *See* Gouache.

erspective The method of describing
ree-dimensional form and effects of
stance by graphic means. The basic
inciple of perspective is that parallel
es receding from the viewer will
ventually appear to converge.

Propellant The mechanism used to supply
air to an airbrush. Cans of compressed air
are available which can be attached to
the airbrush by a valve and airhose, but a
compressor is the most efficient means of
continuous supply.

Rendering 1 The process of developing a
composition from a simple drawing to a
highly finished, often illusionistic image. **2** A
completed image.

Reservoir The part of an airbrush which
contains the supply of medium to be
converted in spray form. In some air-
brushes this is a recess in the body of the
airbrush, in others a color cup mounted on
the airbrush or a jar attached above or
below the paint channel.

Scratching back The process of scraping
paint from a support with a scalpel or
other fine blade to create a highlight area
or remove color when an error has been
made.

Soft edge The effect of using loose masks
or freehand airbrushing to create in-
definite outlines and soften the transition
between one area of an image and the
next.

Soft masking The use of masks held at a
distance from the support surface to soften
the sprayed area, or a masking material
which creates an amorphous effect, such
as cotton balls.

Spatter A mottled color effect of uneven
spray particles produced by using a

specially made spatter cap attachment
for the airbrush nozzle, or by using the
control button to vary the paint/air ratio
within the airbrush.

Spatter cap A nozzle attachment pro-
duced for certain types of airbrush,
designed to produce an uneven spray
effect.

Tone 1 The scale of relative values from
light to dark, visually demonstrated in
terms of the range from black, through
gray, to white, but also applicable to color
effects. **2** Any given value of lightness or
darkness within a picture or design, or in
an individual component of an image.

Transparent medium A medium such as
watercolor or ink which gains color
intensity in successive applications but
does not conceal underlying marks on the
surface of the support.

Watercolor A water-soluble paint con-
sisting of finely ground pigment evenly
dispersed in a gum binder. It is available in
solid and liquid forms; liquid watercolor is
the most useful type for airbrushing.

INDEX

CREDITS

p24-25 Pete Kelly, David Holmes
and Ernst Meir, courtesy of
Meiklejohn illustration; p43, 51
Brian James, courtesy of
Meiklejohn illustration

Demonstrations by Mark Taylor
Diagrams by John Scorey